St Cecilia's Hall

CONCERT ROOM & MUSIC MUSEUM

Museum Highlights

SCALA

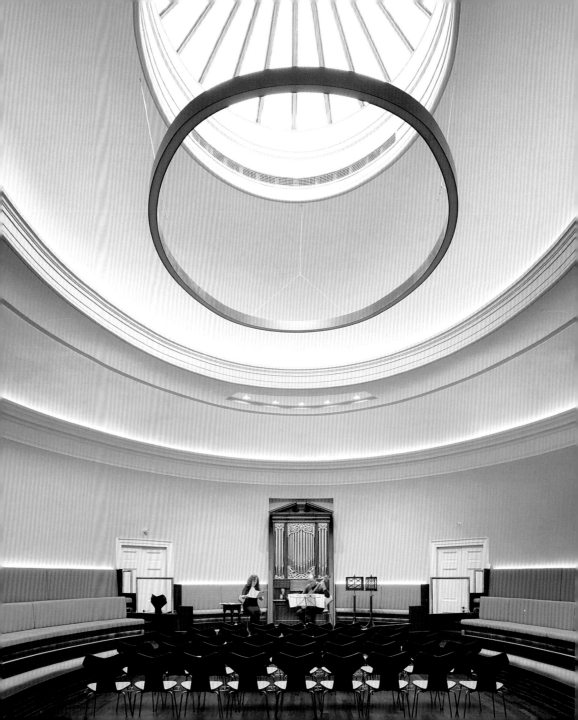

Introduction

St Cecilia's Hall is the oldest purpose-built concert hall in Scotland and home to the University of Edinburgh's collection of musical instruments, including its world-famous harpsichord collection.

Named for the patron saint of music, St Cecilia's Hall has a long and important history. It was designed by Robert Mylne (1733–1811) for the Edinburgh Musical Society and opened in 1763. During its heyday, the Concert Room was *the* venue for some of the best performances in Scotland. This Georgian treasure is a testament to the Scottish Enlightenment and is located just off the Royal Mile in the heart of Edinburgh's Old Town, a UNESCO World Heritage Site.

After closing as a music venue in 1798, St Cecilia's Hall was used for a variety of purposes. Over the years it became a Baptist chapel, Masonic Lodge, school, furniture warehouse, dance hall and even a bar. In 1959 the University of Edinburgh purchased the building to house the Raymond Russell Collection of Early Keyboard Instruments, which were given with the intention of making them available for academic use and public concerts. The building reopened in 1968 as a concert hall and historic keyboard museum.

The Raymond Russell Collection complemented the University of Edinburgh's existing collection of wind, string and percussion instruments, which were on display at the Reid Concert Hall. The Collection's origins can be traced back to John Donaldson (d.1865), Reid Professor of Music, who began collecting instruments for use in teaching in the 1850s.

Thanks to generous gifts from numerous donors, the Collection has grown significantly over the years and now numbers over 5,500 musical instruments. It ranks among the world's most important collections of musical heritage and is a Recognised Collection of National Significance to Scotland.

St Cecilia's Hall reopened in 2017 after undergoing a £6.5 million redevelopment supported by the Heritage Lottery Fund. The new St Cecilia's Hall brings the Collection under one roof, allowing visitors to truly engage with the objects and their stories. The elegant oval Concert Room remains at the heart of the Georgian building and is now complemented by four galleries that display over 500 musical instruments dating from the sixteenth century to today. Many of the instruments in the Collection are still playable and are featured in a dynamic concert programme. The building is open to the public and is a centre for the study, display and enjoyment of musical instruments.

OPPOSITE The oval Concert Room provides excellent acoustics for musical performances. On display in the space is MIMEd 4328, a chamber organ made *c*. 1775 and attributed to James Jones, London.

Virginal

STEPHEN KEENE · LONDON, ENGLAND, 1668

RAYMOND RUSSELL COLLECTION · MIMEd 4308

This beautifully decorated instrument is the largest
and probably the best known of the surviving
English virginals. A type of harpsichord, the
virginal was a domestic instrument used for
practicing and music making within the home.
They were often played by women and the name
virginal probably comes from this association.

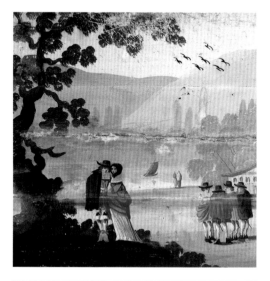

Looking at the sumptuous details of this
fine example one can imagine the interior of the
seventeenth-century home in which it once sat.
The instrument is made of fumed oak with hand-
forged iron hinges. The lid is painted with scenes of
courting couples promenading in a park (complete
with an essential high-class accessory – a poodle);
gilt embossed papers decorate much of the instru-
ment; painted birds and flowers grace the sound-
board; and snakewood, gold and ivory are used on
the keys. This particular instrument sits on a tall
stand, which served a practical purpose: it allowed
women wearing cumbersome dresses to play the
instrument standing up.

The instrument was made by Stephen Keene,
a noted English harpsichord, virginal and spinet
maker. He was born around 1640, probably in
Sydenham in Oxfordshire, and at the age of sixteen
was apprenticed to the noted English virginal
maker Gabriel Townsend in London. Keene is
believed to have died in 1719 and during his long
life he taught numerous apprentices, several of
whom later became noted English keyboard
instrument makers.

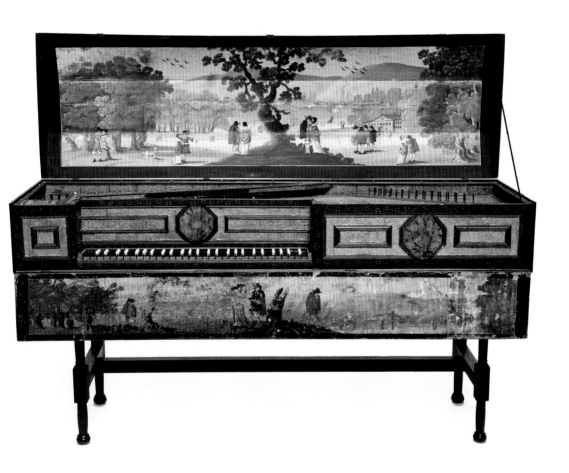

Octave spinet

ATTRIBUTED TO FRANCESCO POGGIO · FLORENCE, ITALY, C.1625
RAYMOND RUSSELL COLLECTION · MIMEd 4311

This is an instrument so small that it could be carried easily around the home or on a journey. Spinets like this were played in many private houses in seventeenth- and eighteenth-century Italy, often to accompany singing.

Although plain on the outside, the interior bears an exquisite rose consisting of several layers of intricately cut parchment in three colours: natural, gold and red. The rose is reminiscent of designs found in the windows of many gothic churches of the period. Due to its three-dimensional shape, this style of rose is often called a 'wedding cake rose'.

The instrument is inscribed with a Latin text above the keys that reads *dum vixi tacui mortua dulce cano*, meaning 'while alive I was silent; now dead, I sweetly sing'. The riddle takes the stance of a tree, which gained a voice when its wood was used to make the instrument.

The spinet is attributed to Francesco Poggio, although it bears an inscription of Petrus Michael Orlandus. Poggio is thought to have been born in Bohemia and may have worked in Venice before settling in Florence. He died in 1634 and many of his instruments have survived to this day. No further details are known of Petrus Michael Orlandus other than that he worked in Italy and repaired this instrument in 1710 in Palermo.

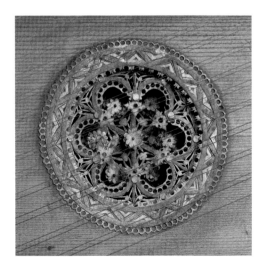

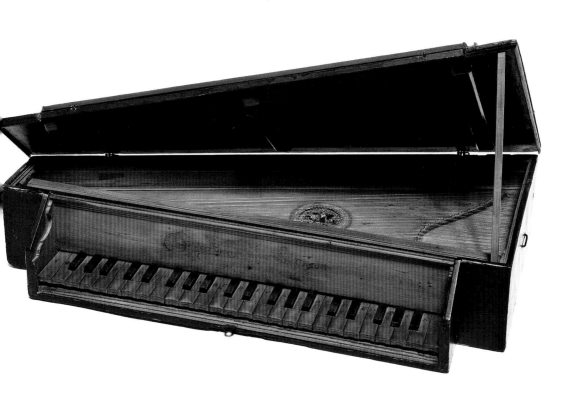

Viola d'amore or treble viol

MAKER UNKNOWN · PROBABLY GERMANY, POSSIBLY C.1720
REID COLLECTION · MIMEd 333

This beautiful instrument is a bit of a mystery. Its shape and decorations are reminiscent of a viola d'amore, but it lacks the sympathetic strings that are usually characteristic of this style of instrument. Additionally this example is larger than the standard instrument, making it difficult to play under the chin with any comfort. Its cumbersome size has led some to surmise that the maker originally intended the instrument to be a viola d'amore but finished it as a treble viol upon discovering it was too large.

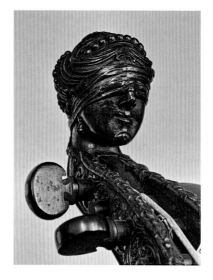

Although the intention of the maker is unknown, the craftsmanship is fine and typical of the work commonly found in German instruments of the early eighteenth century. The instrument is beautifully decorated with ivory inlays on the fingerboard and tail piece. It has a delicate oval-shaped parchment rose that includes the monogram of an unknown owner. The carving on the pegbox is elaborate, the sides feature carved floral work and the back sports renaissance-style strapwork and a grotesque face. The finial carving is the head of a blindfolded woman whose hair is adorned with pearls. This figure is often found on viola d'amores and symbolises the blindness of love. The instrument's sound-holes are another romantic symbol as they are carved in the shape of the 'flaming sword', representing the flames of love.

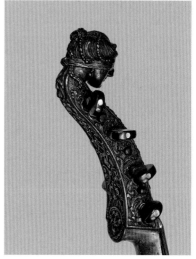

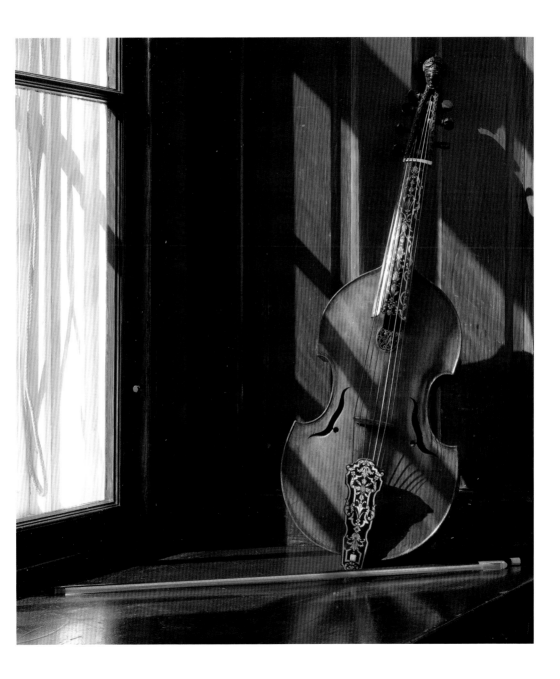

Tenor recorder

BASSANO FAMILY · LONDON, ENGLAND OR VENICE, ITALY, C.1520–50
MIMEd 3921

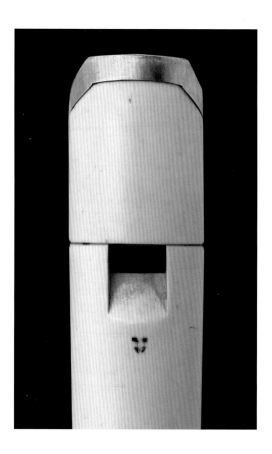

This is the oldest instrument on display at
St Cecilia's Hall. It is an exquisite recorder from
the Renaissance and was made around the time
when the first surviving playing manual for the
recorder was published in 1535 in Venice. It is
made of a single piece of ivory and has inlays at the
mouthpiece and foot. Under the protective cover
called the fontanelle there is a brass butterfly key for
the lowest tone hole. This is 'double touch', meaning
it is designed for right – or left handed use. The
fontanelle, brass key, and inlays are replacements
– originally the instrument was inlaid with gold
and had a fontanelle set with pearls and other small
precious stones.

The valuable materials used to make this
recorder suggest that it was commissioned by a
wealthy and important person. Although we are
unable to trace its complete history, we know that
the recorder was formerly the property of the
Margraves and Grand Dukes of Baden as it is
included in an inventory of their property in 1772.
Baden was a state of the Holy Roman Empire and
later one of the German states.

The instrument is not marked with a maker's
name but instead with the so called 'rabbit's foot' or
'silkworm moth'. This was the mark of the Bassano
family, a highly respected group of musicians and
instrument makers active in Venice and London.
The Bassano family were of Ashkenazi (Spanish)
Jewish extraction, originating from Bassano, a town
north of Venice.

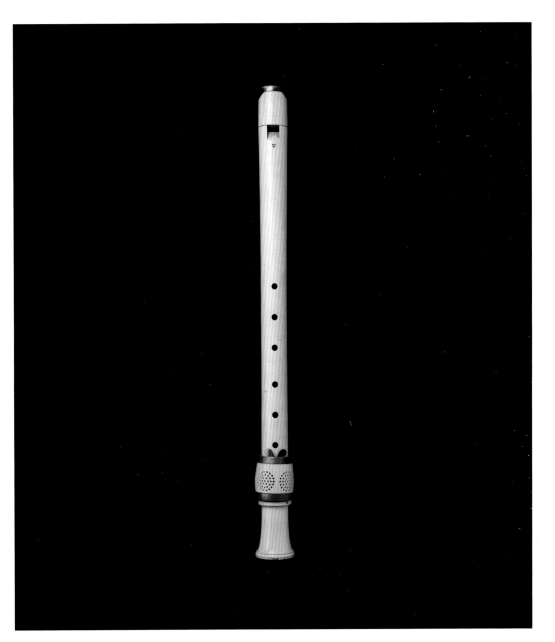

Double-manual harpsichord

IOANNES RUCKERS · ANTWERP, BELGIUM, 1638
RAYMOND RUSSELL COLLECTION · MIMEd 4306

Just as violinists value Stradivarius instruments above all others, there is one family whose harpsichords are the most sought after – the Ruckers family. Established by Hans Ruckers in Antwerp in the 1570s, this dynasty of harpsichord makers included his sons Ioannes and Andreas, and his grandsons Andreas II and Ioannes Couchet.

The Ruckers family pioneered many technical developments in harpsichord design including introducing a second keyboard (called a manual) and strengthening the instrument's body to create a louder, deeper sound. Ruckers harpsichords were so prized that owners extended the instruments' lives by altering them rather than replacing them with newly made instruments.

This is one of the most important instruments on display at St Cecilia's Hall as it is the only known example of a seventeenth-century double-manual harpsichord that has survived with its original, unaligned keyboards. When the instrument was made, the two sets of keys were never expected to be played together as their main purpose was for transposition. As fashion and music tastes changed owners upgraded their instruments so that they could play two keyboards at the same time, and all but this instrument were altered to have matching, aligned keyboards.

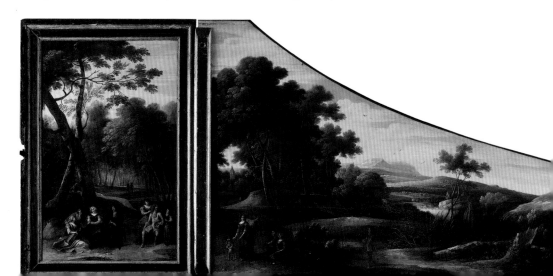

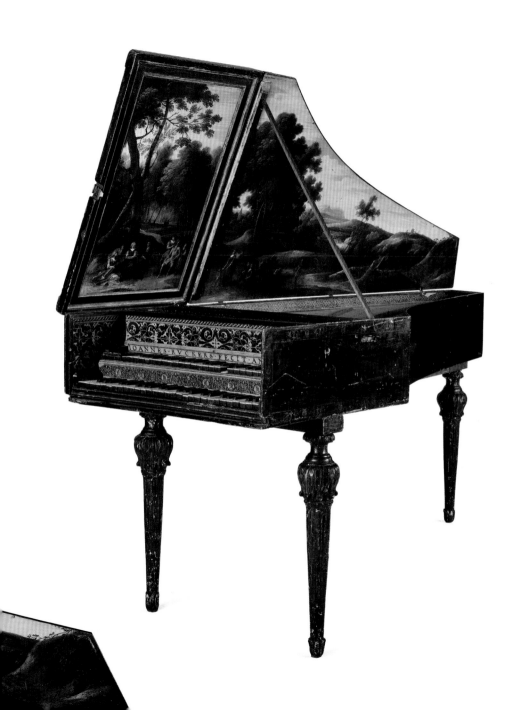

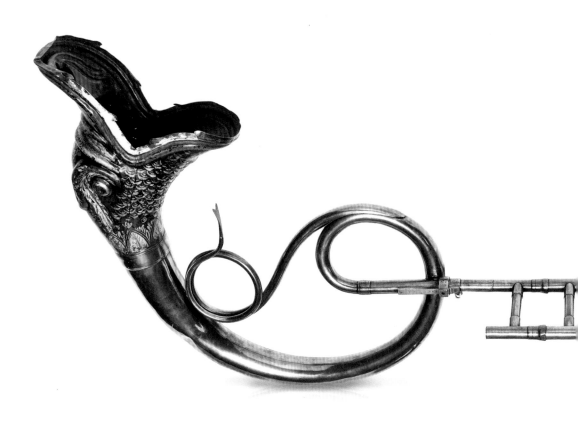

Buccin (trombone)

MAKER UNKNOWN · PROBABLY FRANCE, C.1840

JOHN DONALDSON COLLECTION · MIMEd 0214

This fierce-looking instrument is a type of
stylised trombone that was popular in French
military bands from the early to mid-nineteenth
century. During this time, parades and outdoor
music-making activities were an important part
of French cultural life and uniformed musicians
playing instruments with snake or dragon-headed
bells added to the drama of the events.

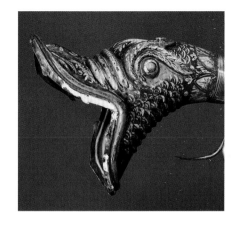

The sound of the buccin is different from that
of today's tenor trombone. Because of the shape
of the bell and the thin brass used in its construc-
tion, it is more reminiscent of a cross between
a trombone and a French horn. It has a warm
and delicate sound when played softly but is also
capable of a ferocious fortissimo.

This buccin's dragon bell is embellished with
red, green and gold paint. Teeth protrude from
the rim of the bell and the curled bell support
ends in a forked tongue. The instrument
is most likely the 'trombone with snake's
head' that was purchased by Professor John
Donaldson for the Music Classroom at the
University of Edinburgh in 1857.

Pair of orchestral horns

MAKER UNKNOWN · ENGLAND, C.1780
LENT BY A. MYERS · MIMEd 2887 & 2888

Orchestral horns were often made and played in pairs and this matched set of horns is typical of the horns played in the eighteenth-century orchestra. Both instruments allow the option of placing additional tubing between the mouthpiece and the body of the instrument. This tubing is called a crook and enabled the player to lengthen the horn and therefore play in a different key. The player would have needed to manually change the crooks between songs or even during rests in the music if the piece changed key.

Orchestral horns were developed from earlier hunting horns, which players would have worn over their shoulder while riding on horseback. Music for early orchestral horns often imitated the sound of the hunt, but by the time these instruments were made the orchestral horn was an integral member of the orchestra with its own distinct melodic and harmonic role and playing technique. To increase the number of notes available on these 'natural' instruments, players used a technique called hand-stopping. This required the player to insert a cupped hand into the bell, thereby modifying the pitch of the note. Although the invention of the valve rendered this technique unneccessary, horn players today still hold their instruments with their hand in the bell.

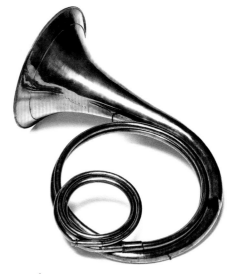

MIMEd 2887

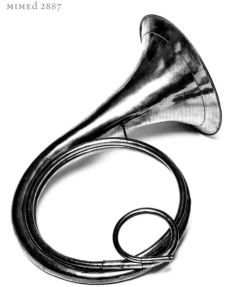

MIMEd 2888

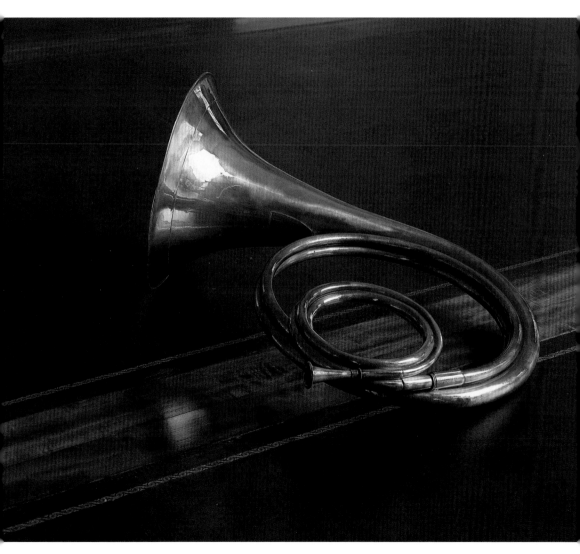

Clarinet in D, 2 keys

MAKER UNKNOWN · PROBABLY GERMANY, C.1740
SIR NICHOLAS SHACKLETON COLLECTION · MIMEd 5168

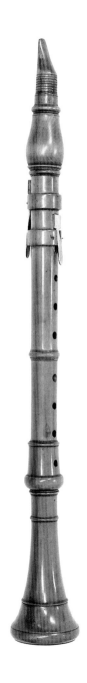

This is the oldest clarinet in the collection and is a rare example of an early version of the instrument. Clarinets were developed around 1700 and the first written reference to them, an order for a pair of clarinets from the maker Jacob Denner, is from 1710. The earliest known compositions for the clarinet were written by Johann Melchior Molter in the 1740s, around the same time that this instrument was made. Crafted from boxwood, it is a rare extant example of an early clarinet with just two brass keys, which was typical at the time. One of the keys is located on the back of the instrument and allows the clarinet to change registers. The register key, along with the flared bell, are features that distinguish the clarinet from its seventeenth-century, single-reed predecessor, the chalumeau.

This instrument is part of the Sir Nicholas Shackleton Collection, the largest collection of clarinets in the world. Shackleton (1937–2006), a distant relative of the Antarctic explorer Ernest Shackleton, was an internationally recognised geologist. Along with his passion for science, music was another of Shackleton's great loves and he was an expert on the history of the clarinet. Over the course of 40 years he assembled an encyclopaedic collection, documenting the history of the instrument over its entire development. On Shackleton's death the Collection was bequeathed to the University of Edinburgh, where it is maintained as a resource for learning and research.

Tenor flute in G or intermediate bass flute, 1 key

CALEB GEDNEY · LONDON, ENGLAND, 1754–69
GIFT OF G.M. GROCOTT · MIMEd 0060

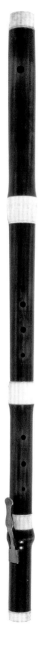

Intermediate bass flutes, also referred to as 'low quint' flutes, were particularly popular in eighteenth-century France, where they were used for solos and as bass instruments in flute trios or quartets. The instruments were pitched a fifth lower than the more commonly played flute in C and they were known for their warm and luxurious sound. In order for the flute to sound lower, the instrument needed to be longer. To make these flutes easier to play keys were sometimes added to help the player cover the finger holes, which were spaced widely apart. Interestingly, this instrument has none of these conveniences and, at almost a metre in length, it could only be played by a flautist with large hands.

This instrument is signed by Caleb Gedney (1729–1769) who was the successor to the famous Stanesby family of flute makers. Gedney was apprenticed to Thomas Stanesby Junior, and upon Stanesby's death in 1754 he bequeathed Gedney all of his tools. However, the inheritance came with a condition: in order for Gedney to claim his property he was required to marry Stanesby's 'late servant Catherine Gale' by whom Gedney had fathered two daughters. The daughters, Catherine and Ann, were brought up in the flute-making business and probably served as unofficial apprentices, helping their father: perhaps they helped to make this flute. Catherine and Ann became skilled makers and when Gedney died they took over the family business.

Viola da gamba

MATTHIAS AND AUGUSTINUS KAISER · DÜSSELDORF, GERMANY, C.1700
MIMEd 2878

The viola da gamba, also called the viol, is a bowed stringed instrument that developed in parallel with the violin. Like violins they come in a variety of sizes from treble to bass, and this instrument is a lovely example of a bass viola da gamba. It was made by two brothers, Matthias and Augustinus Kaiser, who learned to make instruments from their luthier father, Martin. This instrument has refined, elegant decorations including ebony, ivory and fruitwood inlays and a wood-and-parchment rose.

The name *da gamba* translates to 'for the leg', referring to the way the player rests the instrument on their calves when playing. Viola da gambas have a distinct shape: the body is very deep with a flat back and sloping 'shoulders' and many have C-shaped sound holes. They have frets made of gut tied to their necks and may have between five to seven strings.

Bass viola da gambas were widely played as continuo instruments, in viol consorts and as a solo instrument. They were considered a gentleman's instrument and their mellifluous sound was better suited to small ensembles than orchestras. As the orchestra rose in popularity, the viola da gamba was supplanted by members of the violin family, which have a more powerful tone and were better suited to ever larger concert halls. By the end of the eighteenth century viola da gambas had fallen out of use.

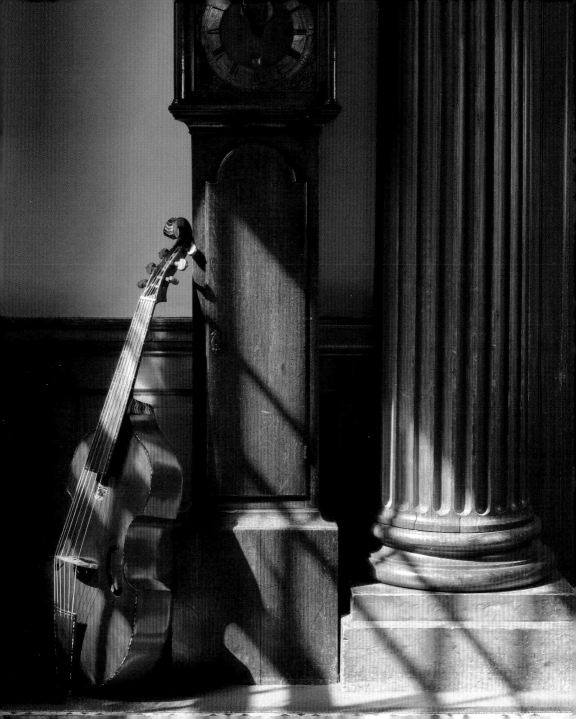

Pastoral pipe

PROBABLY HUGH ROBERTSON · EDINBURGH, SCOTLAND, C. 1775–1800
MIMEd 6184

Pastoral pipes emerged in the eighteenth century and were made throughout the British Isles. These instruments were created for sophisticated players who followed the fashions of the time. In fact, the first book of bagpipe music printed in Britain – John Geoghegan's *The Complete Tutor for the Pastoral or New Bagpipe*, published around 1745 – was written for the pastoral pipes. The name of the instrument is evocative of the musical styles played during the time that romanticised rural life.

This set of bagpipes exemplifies the refined elegance of pastoral pipes. The instrument is made entirely of ivory, with beautiful silver keys and mounts, and would have been owned by a person of wealth. Although it is unsigned, the instrument's construction matches that of those made by Hugh Robertson.

Although popular in the eighteenth century, the pastoral pipe was a short-lived instrument. Rather than fading into obscurity, pastoral pipes were altered and eventually developed into the Union pipe, more commonly known today as the *Uilleann* or Irish pipes.

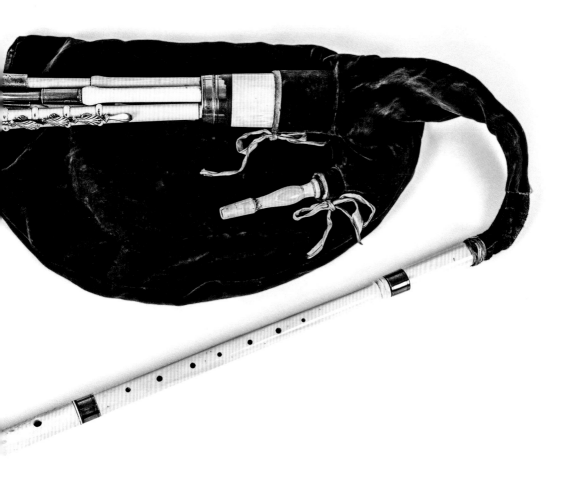

Double-manual harpsichord

PASCAL TASKIN · PARIS, FRANCE, 1769
RAYMOND RUSSELL COLLECTION · MIMEd 4315

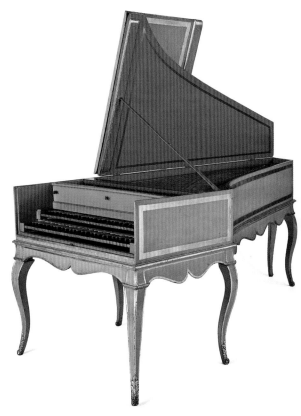

This elegant French instrument is the most famous and most copied harpsichord in the world.

It was made by Pascal Taskin, the court harpsichord builder to both Louis xv and Louis xvi and one of the most famous harpsichord makers in eighteenth-century Paris. Its appearance and decoration are simple and stylish and the sound is particularly rich and opulent. After surviving the turmoil of the French Revolution, the instrument was discovered in a second-hand shop in provincial France and restored in 1882, at a time when few people were interested in harpsichords.

The public renown of the instrument began in 1889, when the pianist Louis Diémer played it in a series of concerts at the Universal Exhibition, the same exhibition for which the Eiffel Tower was built.

Ever since its restoration in 1882 instrument makers have been copying this instrument, but its true fame came in 1965, when a diagram of the harpsichord was published in Frank Hubbard's book *Three Centuries of Harpsichord Making*. Since then countless copies described as 'Taskin 1769s' have been gracing international concert halls around the world.

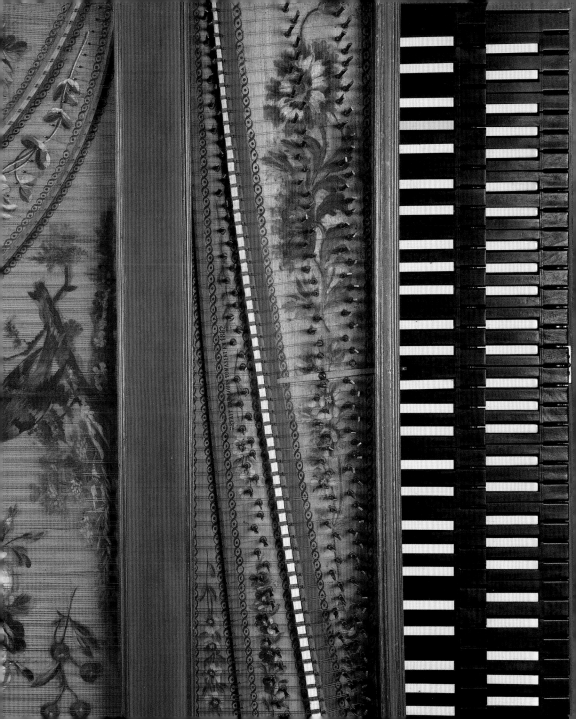

Basset horn in F

RAYMUND GRIESBACHER · VIENNA, AUSTRIA, C.1800
SIR NICHOLAS SHACKLETON COLLECTION · MIMEd 4796

The basset horn is a lower-sounding member of the clarinet family. It was particularly popular in Vienna in the late eighteenth century, from when this instrument dates. The basset horn enjoyed great popularity in the Viennese Masonic Lodges, where it could be played as part of a trio, or provide background music for dinners and other entertainments. Mozart in particular enjoyed the sound of the basset horn and wrote a number of Masonic compositions featuring the instrument.

This basset horn by Griesbacher is made of beautifully stained boxwood with ivory ferrules and brass keywork. The instrument has a flamboyant looking brass bell, above which is the distinctive 'book' or 'box'. The maker was able to double the tubing back on itself within the book, therefore extending the overall length of the instrument while keeping it compact. This instrument originally had eight keys. Seven additional keys were subsequently added.

The Griesbacher firm was established in Vienna by Raymund Griesbacher (1751–1818) who was a member of Haydn's orchestra at Esterhaza, a noted clarinettist and, later, basset-horn player. Griesbacher became the Court supplier of woodwind instruments in 1800 and in 1804 his creations were described by the Austrian author and traveller Joseph Rohrer as 'not needing to fear comparison with any other instruments, and they could be heard throughout Europe'. He was succeeded by his son Raymund II, who became well known for his clarinets.

LEFT Griesbacher included a double-headed eagle, a symbol of the Holy Roman Empire and the later Austrian Empire, in his maker's mark.

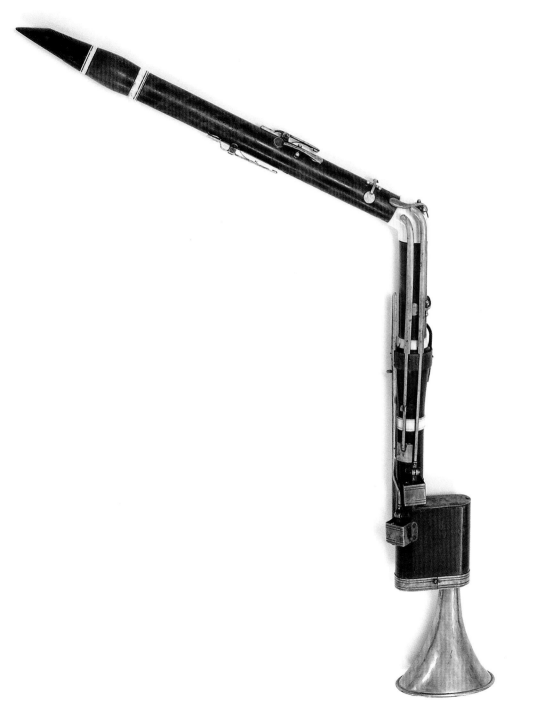

Two archlutes

The most striking feature of these two lutes is their very long necks. Stretching well over a metre in length, the necks support a set of eight gut bass strings. The addition of bass strings to the lute made the instrument more versatile and was an enhancement of the earlier Renaissance lute. At this time, long strings were required to produce low notes and so the necks were lengthened to support them. Also noteworthy are the delicately worked geometric roses on the front of the lutes. Carved directly out of the soundboard, these roses act as the sound hole and so are as practical as they are beautiful.

Archlutes once provided improvised accompaniment for singers. They were also played as solo instruments, in ensembles, and even found a key role in the orchestras of the day due to their powerful, penetrating sound. Archlutes were most commonly played in Rome, where both of these instruments were made.

Interestingly, both of these instruments were made by German luthiers living in Italy. More is known about Martinus Harz, who was born in Füssen in Bavaria around 1624 and had a large workshop in Rome that employed several apprentices and workers. Unfortunately, little is known about Cinthius Rotundus and this lute is his only surviving instrument.

ARCHLUTE · MARTINUS HARZ ·
ROME, ITALY, 1665
ANNE MACAULAY COLLECTION · MIMEd 0300
ILLUSTRATED OPPOSITE LEFT

ARCHLUTE · CINTHIUS ROTUNDUS ·
ROME, ITALY, 1699
C. H. BRACKENBURY MEMORIAL COLLECTION ·
MIMEd 1051
ILLUSTRATED BELOW AND OPPOSITE RIGHT

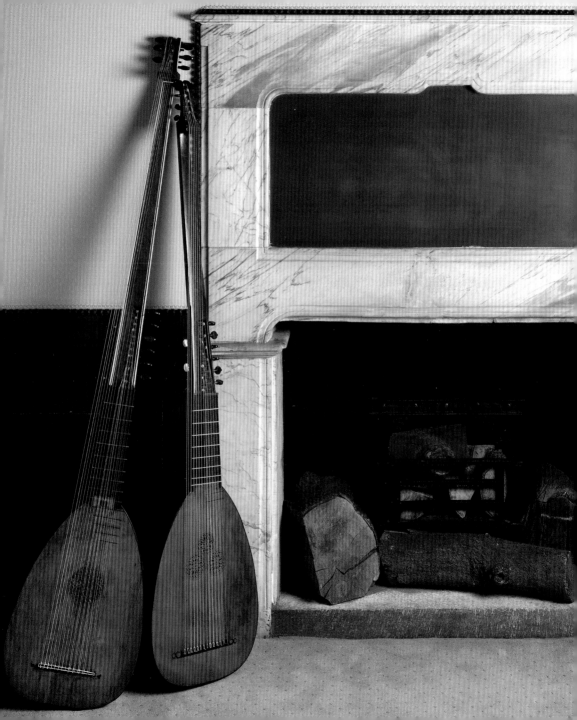

Double-manual harpsichord

JEAN GOERMANS · PARIS, FRANCE, 1764; ALTERED BY PASCAL TASKIN, PARIS, FRANCE, 1780S
RAYMOND RUSSELL COLLECTION · MIMEd 4329

This stunning instrument was made by Jean Goermans (1703–77), but for well over one hundred years it was believed to have been made by Ioannes Couchet, a member of the famous Ruckers family who had lived a century earlier. The deception was deliberate: the harpsichord maker Pascal Taskin had altered the instrument to look like a Couchet so that he could sell it for a highly inflated price.

In order to succeed in his ruse, Taskin made the harpsichord appear older. He redecorated the case, darkened the soundboard beneath the strings and transformed the maker's initials on the rose from IG to IC, representing Ioannes Couchet. Taskin also added to the harpsichord by introducing knee levers and a *peau de buffle*, a set of jacks with soft leather plectra that provide a soft, piano-like tone.

Through his alterations, Taskin created a gorgeously decorated instrument with a delicate and sophisticated sound. Despite its background as a forgery, it is one of the finest harpsichords in any collection in the world.

RIGHT Elegant chinoiserie patterns in black, red and gold were added by Taskin in the 1780s. The decorations include scenes from nature as well representations of domestic life.

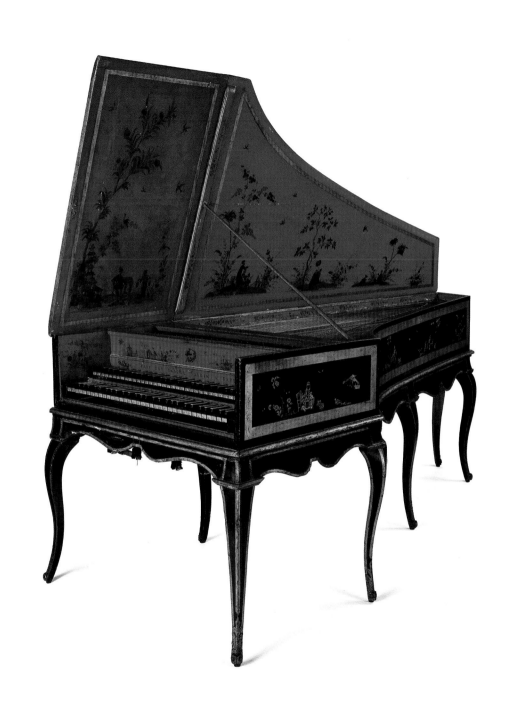

Keyed trumpet in E-flat

LOUIS MÜLLER · LYON, FRANCE, C.1835
LENT BY A. MYERS · MIMEd 3158

The natural trumpet was notoriously difficult to
play. In order to make it easier, several players and
instrument makers in the late eighteenth century
experimented with adding keys to the trumpet,
enabling musicians to play chromatic music. Anton
Weidinger, a trumpet virtuoso, was particularly
influential in the development of the keyed trum-
pet's design. In 1796 Joseph Haydn, a friend of
Weidinger, composed his *Trumpet Concerto in E-flat
major* to demonstrate the ability of the new keyed
trumpet. Keyed trumpets were used extensively in
the first half of the nineteenth century, but although
they were more flexible than the natural trumpet,
their poor sound quality meant that they were later
replaced by trumpets with valves.

This instrument has six keys, all of which were
played by the player's right hand. The keys were
opened one at a time and not in combination. The
instrument was made by Louis Müller (d.1867),
who worked under his uncle, François Antoine
Sautermeister. When his uncle died in 1830, Müller
became a partner in the firm with his aunt before he
established his own workshop in 1835. Like many
instrument makers of his day Müller experimented
with instrument design and patented many of his
creations, most of which have fallen into obscurity.

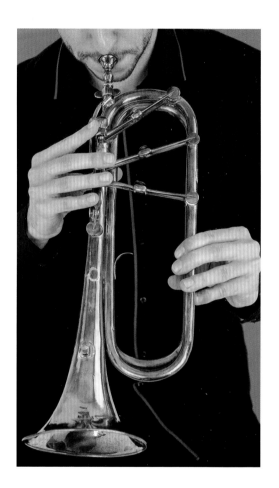

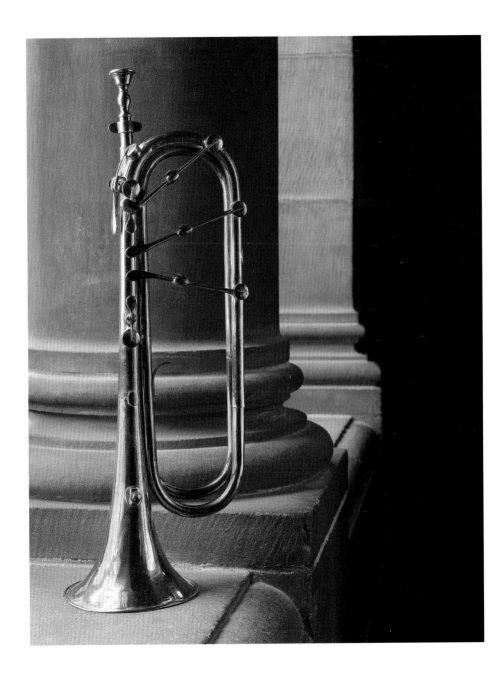

Violins without sides

ATTRIBUTED TO THE BASSANO FAMILY · PROBABLY LONDON, ENGLAND,
LATE 16TH OR EARLY 17TH CENTURY

REID COLLECTION · MIMEd 329 & 5851

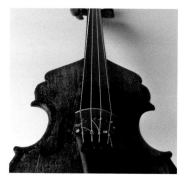

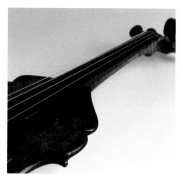

Although there has been significant research done on these two unusual instruments, their history and use remain a mystery. It was believed that they were made in the sixteenth century when the violin was relatively new and when Italy was the world leader in violin construction. However, it is likely that these wafer-thin, oddly-shaped instruments were produced in England.

Called 'violins without sides', both instruments possess a soundboard and back, but neither have ribs. The body shape is more reminiscent of some early English viols than the violin, and one of the instruments bears ink decoration very similar in design to that found on English virginals of the late sixteenth to mid seventeenth century. In each corner of the decorated instrument is a moth, which has led some to suggest that the instrument could be the work of the Bassano family – leading instrument makers to the Tudor court. However, as of yet, scientific analysis of the violins – including wood identification, dendrochronology (the dating of wooden objects based on tree-ring patterns) and analysis of the varnish – has been inconclusive. The origins of these violins remain a mystery, and given their peculiar design we are not sure whether we should call them violins at all.

MIMEd 329 ILLUSTRATED LEFT
MIMEd 5851 ILLUSTRATED OPPOSITE

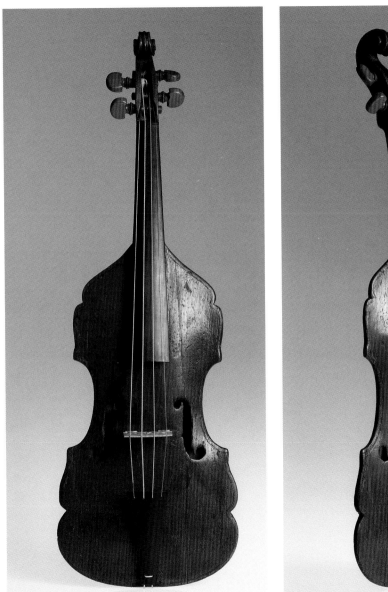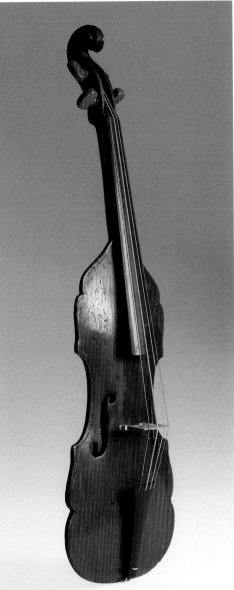

Double-manual harpsichord

JACOB KIRKMAN, ALSO KNOWN AS KIRCKMAN · LONDON, ENGLAND, 1755
RAYMOND RUSSELL COLLECTION · MIMEd 4330

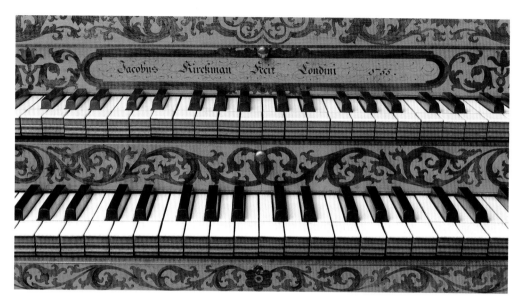

Jacob Kirkman was one of the most in-demand harpsichord makers of eighteenth-century London and he spared no expense on this instrument. With elaborate decoration that may be admired from all angles, it made an impressive centrepiece for a grand room. In addition to the beautifully veneered outer case, the instrument has intricate marquetry on the interior complete with floral designs, the maker's monogram and fierce eagles. The carved stand with claw and ball feet is also an unusual luxury on a harpsichord of the period.

This instrument demonstrates how harpsichord makers were highly skilled craftsmen who combined expert woodworking and metalworking. Many also ran their own businesses in cities that were full of competing workshops. The most successful, like Jacob Kirkman, used innovative design, client-friendly finishes and clever marketing to seek out customers, build their reputation and boost the value of their instruments.

Kirkman, born in 1710 in the Alsatian town of Bischweiler in modern-day Germany, came to England in the early 1730s. Initially he worked for the Flemish harpsichord maker Hermann Tabel, and when Tabel died Kirkman married his widow and took over the workshop. Kirkman was extremely successful and included kings, queens and other nobility among his customers. He died in 1792.

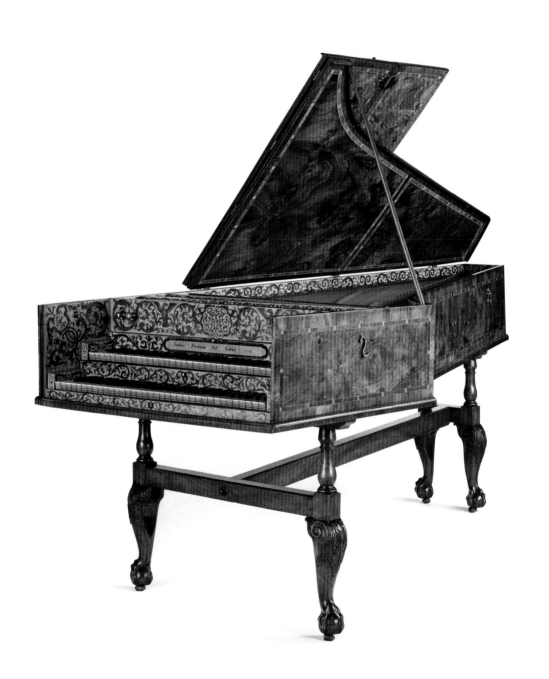

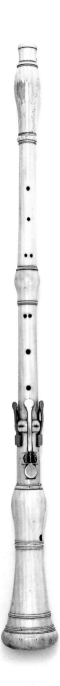

Three oboes

These are three exceptional examples of early oboes, each made just a couple of decades after the invention of the instrument in France towards the end of the seventeenth century. The oboes were played with a double reed that the player controlled with their lips and had a quieter and more refined sound than their predecessor, the shawm, making them perfect for orchestral use.

At the time these oboes were made, many woodwind instruments were constructed so that the player could decide which hand to place at the top or the bottom. Two of the oboes have three keys, one of which was a duplicate, and all three share the distinct 'swallow tail' shaped centre key. The player would therefore have been able to determine their own hand position.

The three oboes demonstrate the elegant design of early instruments and each is made of a different material: ivory, boxwood, and an exquisite rosewood and ivory combination. The boxwood instrument was made by Thomas Stanesby Senior (1668–1734) and is one of the earliest known English oboes. The Stanesby family were London-based woodwind makers who worked during the eighteenth century and were responsible for most of the finest surviving English baroque woodwind instruments. Sadly, the makers of the other two instruments are unknown.

IVORY OBOE ·
MAKER UNKNOWN ·
PROBABLY FRANCE, C.1700
C. H. BRACKENBURY MEMORIAL
COLLECTION · MIMEd 1032
ILLUSTRATED LEFT

BOXWOOD OBOE ·
THOMAS STANESBY SENIOR ·
LONDON, ENGLAND, C.1700
GEOFFREY RENDALL COLLECTION
MIMEd 0062
ILLUSTRATED OPPOSITE LEFT

STRIPED OBOE ·
MAKER UNKNOWN ·
PROBABLY FRANCE, C.1710
C. H. BRACKENBURY MEMORIAL
COLLECTION · MIMEd 1033
ILLUSTRATED OPPOSITE RIGHT

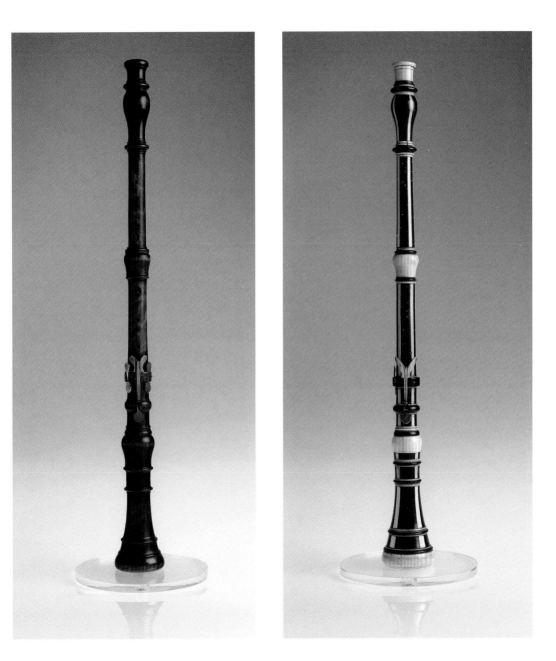

Hardanger fiddle (or hardingfele)

ÅSMUND V. KÄLLÅR · MOGEDAL, TELEMARK, NORWAY, 1929

GIFT OF SIR GERALD ELLIOT · MIMEd 2368

This beautifully decorated string instrument is an example of a traditional Norwegian fiddle. Although its shape is similar to that of the violin, there are subtle distinctions that affect the sound. One noticeable difference is the number of strings – this example has eight in total. Four of the strings are bowed like a violin, while the others ring sympathetically. The bridge of a Hardanger fiddle is relatively flat compared to the bridge of a violin, allowing the player to bow two or three strings at a time. This example is decorated with mother-of-pearl and bone inlays on the fingerboard and tail piece. Ink decorations called 'rosing' cover the body and the Lion of Norway, a symbol from the country's coat of arms, adorns the pegbox.

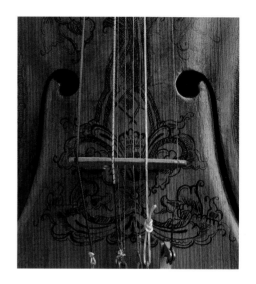

The earliest known example of a Hardanger fiddle dates from 1651 and was made by Ole Jonsen Jaastad in the Hardanger region of Norway. Although traditionally the instrument was mainly played in the southwest part of the country, today it is often called the national instrument of Norway. The fiddle is used to accompany dancing and more than 1,000 distinct tunes have been notated for the instrument.

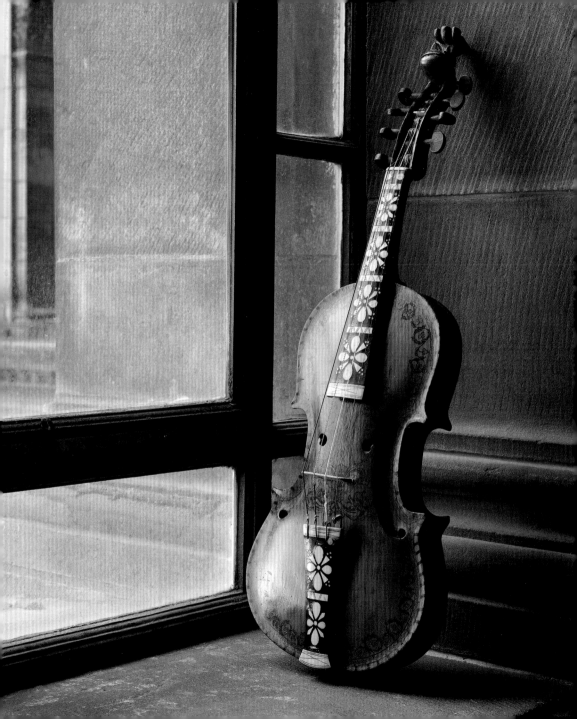

Turkish crescent

MAKER UNKNOWN · PROBABLY FRANCE, 19TH CENTURY
FRANK TOMES COLLECTION · MIMEd 6110

This instrument is known variously as the Turkish crescent, the *chapeau chinois* ('Chinese hat' in French), *Schellenbaum* ('bell tree' in German) and the Jingling Johnny. The Turkish crescent was originally played by the elite Janissary bands of the Ottoman Empire, but when Turkish music became *en vogue* during the eighteenth century it was appropriated by European military bands. The instrument is held vertically when played and is shaken or twisted by the performer, much like the baton used by drum majors today.

The Turkish crescent was at its most popular in European military bands from around 1750 to 1850. The British Army stopped using the 'Jingling Johnny' in 1837 and many bands replaced it with the glockenspiel, which could play a melody. A few military bands in continental Europe still play the Turkish crescent but its use is mostly symbolic, functioning more as a standard or banner than a musical instrument.

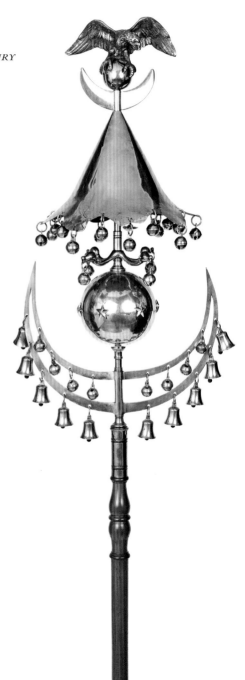

Tam-tam

MAKER UNKNOWN · CHINA, C.1930
JAMES BLADES COLLECTION · MIMEd 2889

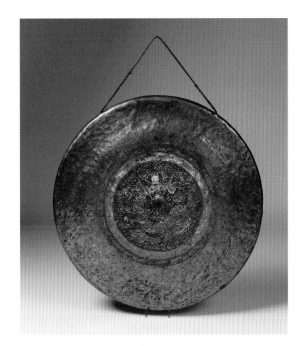

This Chinese gong is an instrument that many people, especially film lovers, have heard but never seen.

This example was one of a batch of three tam-tams imported from China by the Premier Drum Company in 1934. It was purchased by the English percussionist James Blades, one of the most distinguished percussionists in Western music. Blades used the tam-tam in orchestral performances and in teaching but its path to fame began in 1935. At that time, Blades was invited to record the three gong strokes used for the opening sequence of General Film Distributors, later known as Rank Film Distributors. Rank Films are known for the iconic 'gongman' seen striking a gong at the beginning of each film, but the instrument that appears on-screen was actually a papier-mâché model. This tam-tam is the instrument whose sound is dubbed over the film.

Initially James Blades had to record this gong every couple of months, but as recording technology improved the instrument was recorded less frequently. Blades occasionally re-recorded the gong up until 1980, but unfortunately after the last recording session the instrument suffered slight damage in transit and is no longer playable. However, its sound lives on at the beginning of countless films.

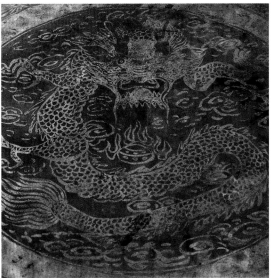

Stroh violin

STROVIOLS · ENGLAND, 1910–20
LENT BY A. MYERS · MIMEd 4533

The Stroh violin was developed at the dawn of the recording age by Augustus Stroh (1828–1914). Born in Frankfurt, Germany and settling in London in 1851, Stroh was an electrical engineer who specialised in acoustics and the telegraph. This strangelooking instrument, which Stroh developed between 1899 and 1901, was specifically designed so that the phonograph, the recording technology of the day, would be able to pick up the sound of the violin.

Stroh's violin does not have a traditional wooden body. Instead, the instrument used a round, flexible metal membrane as a resonator and a large aluminium horn to project the sound directly into the recording horn of the phonograph. The second, smaller horn allowed the musician to hear their own performance better.

Although mainly made of metal, the tone of instrument is surprisingly not metallic, but it is strident. These instruments were quickly adopted in recording studios and a whole violin family was developed, as were mandolins, guitars and banjos. The instruments became obsolete in the second half of the 1920s with the adoption of electric microphone recording, but they continue to be popular with jazz and folk musicians today.

BELOW This famous photograph from 1908 encapsulates the technical problems and limitations imposed by phonograph recording. The image shows conductor Bruno Seidler-Winkler leading the Deutsche Grammophon Orchestra, accompanying the tenor Karl Jörn. The Stroh violins are clearly visible.

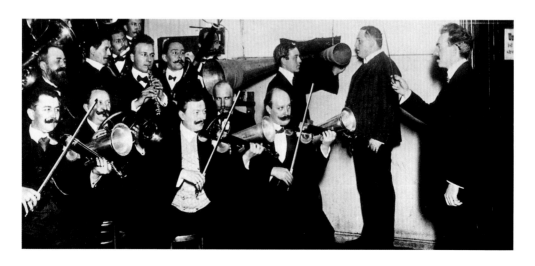

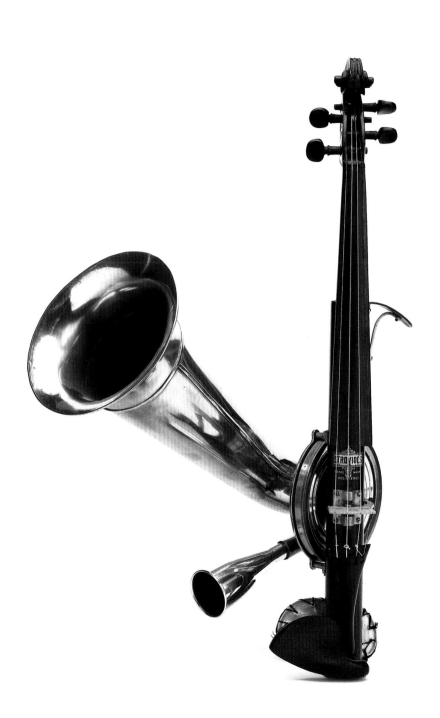

Two natural trumpets

These lovely trumpets were made in London, a centre of brass instrument making in the eighteenth century. They are typical of the trumpet design of the time: both are constructed of thin metal tubes, with a distinctive ball to protect the joint of the tube and the bell, and an ornately decorated 'garland' which reinforced the bell's flared end. These trumpets could have been played for a number of ceremonial functions or in an orchestra. In fact, the silver instrument was played in an orchestra organised by Sir Samuel Hellier (1737–1784), an ardent collector of musical instruments and music.

Both of the instruments are 'natural' trumpets, meaning they have no valves or keys. In the lower register there are wide gaps between the notes that they can play. Although in the higher register diatonic melodies are possible, it takes an incredibly skilled musician to play the natural trumpet well.

The instruments were made by two well-known eighteenth-century brass makers: Nicholas Winkings, described as 'Horn Maker to the Royal Hunt', and John Christopher Hofmaster (d.1764), a German immigrant who followed George Frideric Handel to London and established his firm there around 1751.

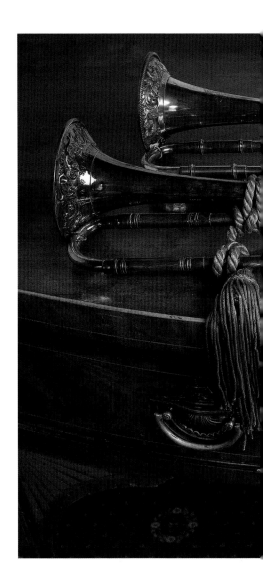

NATURAL TRUMPET IN E-FLAT · JOHN CHRISTOPHER HOFMASTER · LONDON, ENGLAND, C.1760
SHAW-HELLIER COLLECTION · MIMEd 3280
ILLUSTRATED TOP

NATURAL TRUMPET IN D · NICHOLAS WINKINGS · LONDON, ENGLAND, 1751–68
SHAW-HELLIER COLLECTION · MIMEd 3282
ILLUSTRATED BELOW

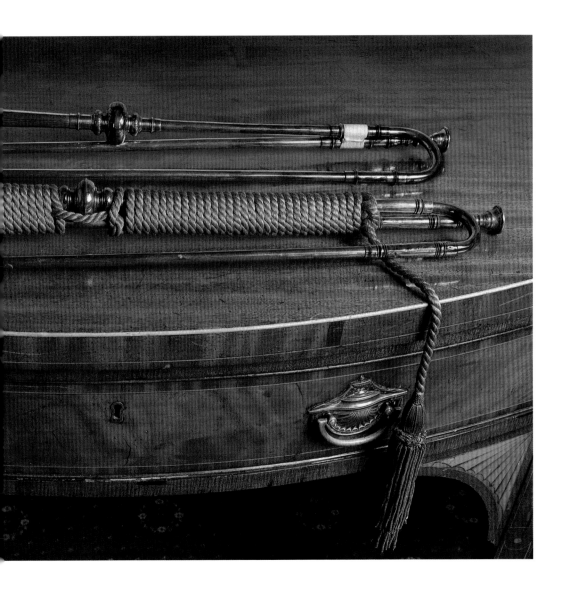

Clavichord

JOHANN ADOLPH HASS · HAMBURG, GERMANY, 1763
RAYMOND RUSSELL COLLECTION · MIMEd 4322

This instrument is a fine example of a large German clavichord. It was made by Johann Adolph Hass (d. 1776), who, like his father Hieronymus, was known for his richly decorated instruments. This clavichord is sumptuous in its detail, made from the finest materials imported from all over the world. The ivory-fronted keys are covered with tortoise-shell and mother-of-pearl and the interior of the instrument's case is lined with exotic wood veneers. Three different styles are used in the decoration: flowers are painted on the soundboard; a pastoral scene adorns the inside of the lid; and the exterior is covered in ornate Chinese motifs known as *chinoiserie* painted in silver and gold on a vermilion red background. Today these different styles might seem to clash, but the decoration was at the height of fashion in eighteenth-century Europe.

Clavichords are intimate instruments. Their soft, delicate sound made them ideal for accompanying singing or as a solo instrument, but this gentle sound also limited their performance to the parlour rather than the concert stage. The playing technique of the clavichord is nuanced as it is incredibly responsive to the player's touch, and many musicians, especially organists, had clavichords in their homes as practice instruments. This lavishly decorated clavichord would have been a beautiful domestic instrument for its wealthy owner.

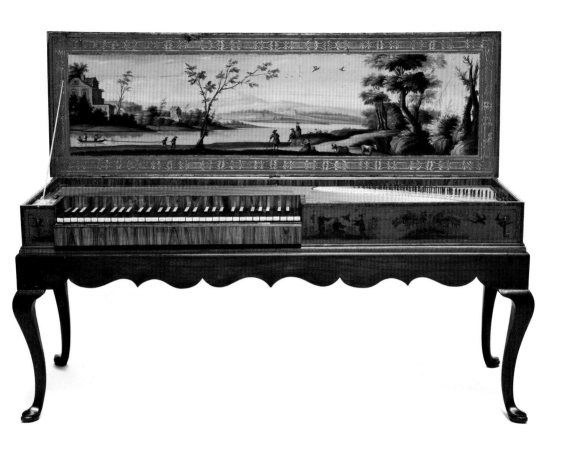

Tenoroon (tenor bassoon)

J. N. SAVARY · PARIS, FRANCE, 1840

REID COLLECTION · MIMEd 169

Bassoons were once made in a variety of sizes and this tenoroon (a contraction of tenor bassoon) sounded a fifth higher than today's standard bassoon. Not a lot of music was written for the instrument and it is surmised that they were mainly made for children to learn how to play the bassoon and for use in bassoon ensembles.

This example is finely made and has an unusual feature: an extra wing joint, which lowers the pitch of the bassoon. In the nineteenth century there was no international standard for tuning the pitch of an instrument and so the pitch of instruments or entire orchestras could vary from city to city and concert hall to concert hall. Instruments were therefore produced with additional parts that could be swapped to change their pitch if required. The additional wing joint on this instrument meant that the player was expecting to play in more than one ensemble or city.

This tenoroon was made by Jean Nicholas Savary (1786–1853), a French woodwind instrument maker who pioneered improvements to the bassoon. He had an international reputation and his bassoons remained popular in England until the early twentieth century, even earning him the nickname of the 'Stradivari of the bassoon'.

Tenor trombone

ANTON SCHNITZER · NUREMBERG, GERMANY, 1594
MIMEd 2695

This is one of the oldest playable trombones in the
world. It looks similar to the modern trombone,
but it has a smaller bell and the sound is much
gentler. It was made in Nuremberg, then a small
city-state, which had a monopoly in Europe on brass
instrument making at the time. Production was
tightly controlled by the city's guilds, who exported
instruments across Europe but prevented master
instrument-makers from leaving the city for fear they
might share their trade secrets.

Engraved around the beautifully decorated bell
garland is the maker's mark: Anton Schnitzer,
and the date 1594. Anton Schnitzer (d. 1608) was
born into a family of brass instrument makers from
Munich. They moved to Nuremberg and Anton
first appears in court documents when he became
a citizen of the city in 1558. He became a master in
1562 and his son, Anton 'the Younger', followed
in his father's footsteps and became a master in
1591. Since both Anton 'the Elder' and Anton 'the
Younger' signed their instruments in the same way,
it is difficult to know whether the father or the son
made this fine trombone.

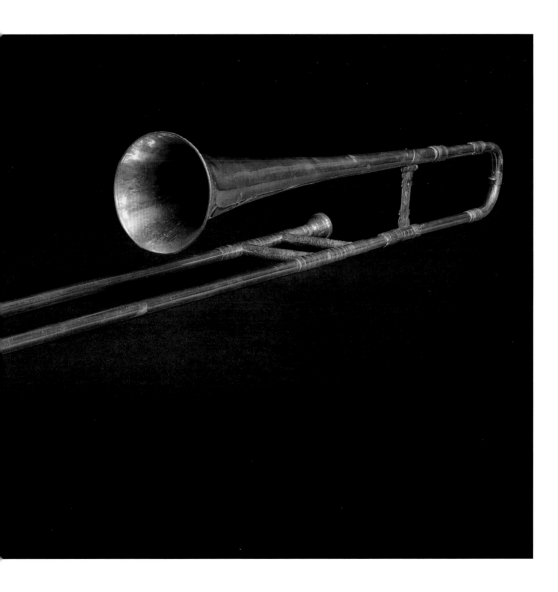

Broadwood harpsichord and pianoforte

These instruments look very similar, but the instrument on the left is a harpsichord and the other is a piano. Made by John Broadwood & Sons in 1793, the instruments were constructed during a time when the piano was fast becoming the instrument of choice for both private homes and concert halls. Keyboard makers like Broadwood made both types of instrument, and although customers who swapped their harpsichords for early pianos may have gained a more fashionable sounding instrument, their new purchase probably looked much the same.

This harpsichord has a Venetian swell; a set of wooden slats that cover the strings. A pedal controls the swell and depending on whether the slats are open or closed, the player can alter the volume of the instrument. This device was common on later harpsichords and allowed for a greater range of expressive playing. Despite this clever mechanism, by this time the harpsichord was becoming passé and instrument makers were focusing increasingly on piano production. In fact, this is the last known harpsichord made by Broadwood and after its completion he switched entirely to piano building.

SINGLE-MANUAL HARPSICHORD · JOHN BROADWOOD & SONS · LONDON, ENGLAND, 1793
RAYMOND RUSSELL COLLECTION · MIMEd 4319
ILLUSTRATED BELOW

GRAND PIANOFORTE · JOHN BROADWOOD & SONS · LONDON, ENGLAND, 1793
RODGER MIRREY COLLECTION
MIMEd 4490
ILLUSTRATED OPPOSITE

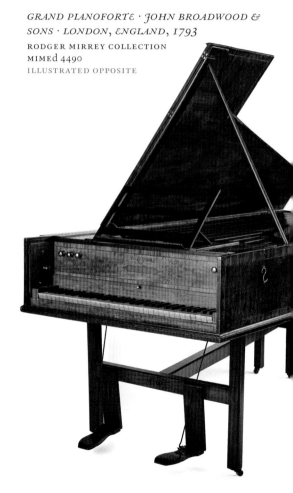

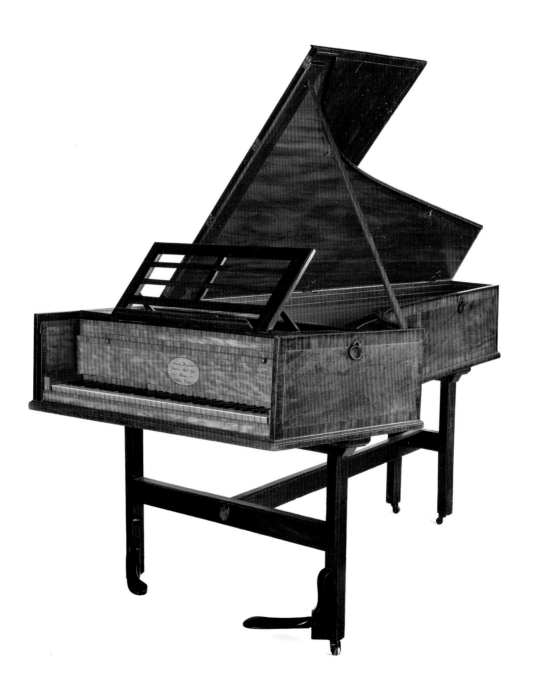

Three mandolins

The mandolin, which was developed in the seventeenth century, is a member of the lute family. It was especially popular in eighteenth-century Italy when each region developed its own style of mandolin, using different body shapes, numbers of strings and tunings.

These three instruments highlight the diversity of designs and decorations used in eighteenth-century Italian mandolin construction. The mandolin by Angelo Bergonzi (1721–1758) is particularly interesting with its petite size, intricately carved rose and engraved ivory decorations, including a grotesque face. The other two instruments were both made in Naples and are most likely by members of the Vinaccia instrument making family, who were active from the mid-eighteenth century until the early twentieth century. Although they differ slightly in shape and number of strings they share decorative techniques, especially the use of mother-of-pearl and tortoiseshell inlays, which came to be a common feature of later Italian mandolins.

NEAPOLITAN MANDOLIN, 6 COURSES ·
PROBABLY VINACCIA FAMILY · NAPLES, ITALY,
EARLY 18TH CENTURY
ANNE MACAULAY COLLECTION · MIMEd 303
ILLUSTRATED OPPOSITE, LEFT TOP

NEAPOLITAN MANDOLIN, 4 COURSES ·
PROBABLY VINACCIA FAMILY · NAPLES, ITALY,
18TH CENTURY
LENT BY NATIONAL MUSEUMS OF SCOTLAND · MIMEd
3374 (A1869.9.35)
ILLUSTRATED OPPOSITE, LEFT BELOW

LOMBARDO MANDOLIN, 6 STRINGS ·
ANGELO BERGONZI · CREMONA, ITALY, 1755
C. H. BRACKENBURY MEMORIAL COLLECTION
MIMEd 1061
ILLUSTRATED OPPOSITE, RIGHT AND DETAIL BELOW

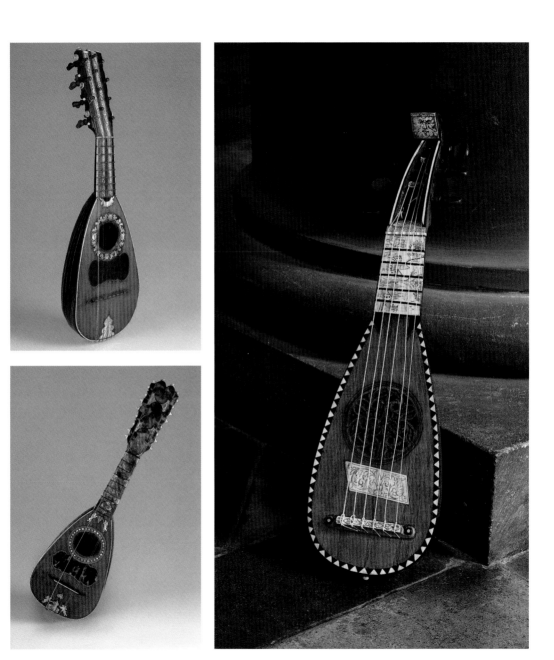

Pūtōrino (end-blown trumpet and flute)

MĀORI PEOPLE · NEW ZEALAND, BEFORE 1855
REID COLLECTION · MIMEd 0383

The Māori pūtōrino is an instrument that can be played either as a trumpet or as a flute. It is a traditional instrument of Aotearoa, the Māori name for New Zealand, and is used to signal over large distances and for musical accompaniment.

The instrument is made from a piece of split wood that is shaped, hollowed out and then bound tightly together. It is held together with delicately braided vegetable fibre, traditionally made from a vine or kiekie root. The craftsmanship of this instrument is so fine that it is difficult to see the join of the two halves on either side. The sound hole is carved to represent a human mouth and surrounded by a depiction of a face representing Hineraukatauri, the goddess of music and dance.

The sound is said to be masculine in quality when played as a trumpet and feminine in nature when played as a flute. In both methods the musician alters the pitch by using a finger to cover or uncover the central hole.

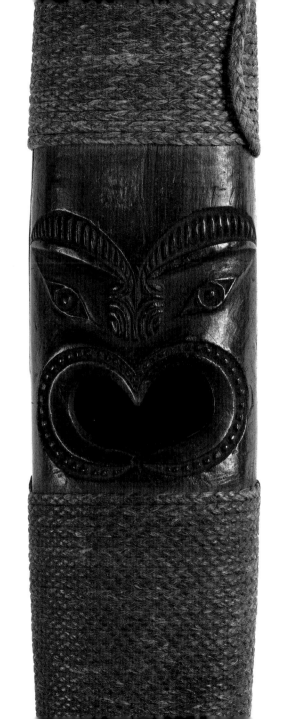

Quartet of saxophones

ADOLPHE SAX · PARIS, FRANCE, 1856–60
MIMEd 4421–4424

This early set of saxophones was made by their inventor, Adolphe Sax (1814–1894). Aiming to create an instrument with the volume of a brass instrument and the agility of a woodwind, Sax began working on a design for the saxophone in the early 1840s. In the course of his experiments he added a clarinet-like mouthpiece to the body of an ophicleide, a bass keyed brass instrument used at the time. Sax's 1846 patent for the saxophone clearly shows his invention process. He went on to create saxophones in a variety of sizes, ranging from the sopranino to the subcontrabass. This quartet shows the sizes most commonly played today: soprano, alto, tenor and baritone.

Adolphe Sax was born in Belgium and started his career working in his father's workshop before establishing his own business in Paris at the age of 28. He was a noted inventor and player, and today he is best known for inventing the saxophone and a family of brass instruments called saxhorns. He was a very controversial figure during his lifetime, both admired and detested by many. Sax was notoriously litigious and throughout his career he was embroiled in a number of lawsuits against rival instrument makers. The lawsuits bankrupted him twice – in 1856 and 1873. Today, Sax's legacy lives on through his two main inventions, both of which have become incredibly well used in military bands and in popular music.

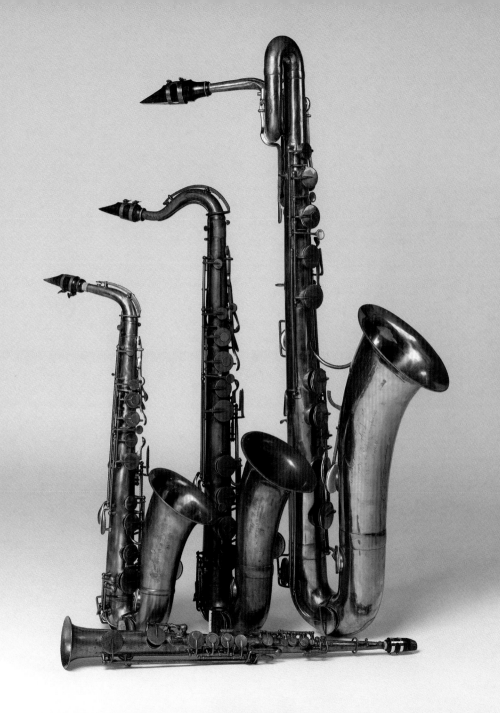

Romantic guitars

The six-string guitar first appeared towards the end of the eighteenth century, probably in the Italian city of Naples. In addition to a new arrangement of strings, many of these instruments had larger bodies than earlier guitars and mechanical tuners, which helped hold the strings taut. These modifications not only made the guitar louder, but also increased its appeal with amateur musicians.

By 1820 this style of guitar had become hugely popular across Europe, with virtuoso guitar players such as Fernando Sor touring the continent. The music played on these instruments was from the Romantic era (*c*.1780–1910), giving the guitars their name.

The five guitars pictured were made by some of the most well-known makers of the period, each of whom left their own innovative mark on the development of the guitar. These makers worked with leading composers and performers, such as Niccolò Paganini and Mauro Giuliani, and their designs shaped the acoustic guitar we know today.

LEFT TO RIGHT:

GUITAR, 6 STRINGS · RENE LACOTE · PARIS, FRANCE, C.1830
GIFT OF WILFRID APPLEBY · MIMEd 2521

GUITAR, 6 STRINGS · LOUIS PANORMO · LONDON, ENGLAND, C.1845
GIFT OF WILFRID APPLEBY · MIMEd 2522

GUITAR, 6 COURSES · JOSEF PAGES · CADIZ, SPAIN, 1813
ANNE MACAULAY COLLECTION · MIMEd 0282

GUITAR, 6 STRINGS · GENNARO FABRICATORE · NAPLES, ITALY, 1822
ANNE MACAULAY COLLECTION · MIMEd 0770

GUITAR, 6 STRINGS, 'LEGNANI' MODEL · JOHAN GEORG STAUFER · VIENNA, AUSTRIA, 1829
MIMEd 3838

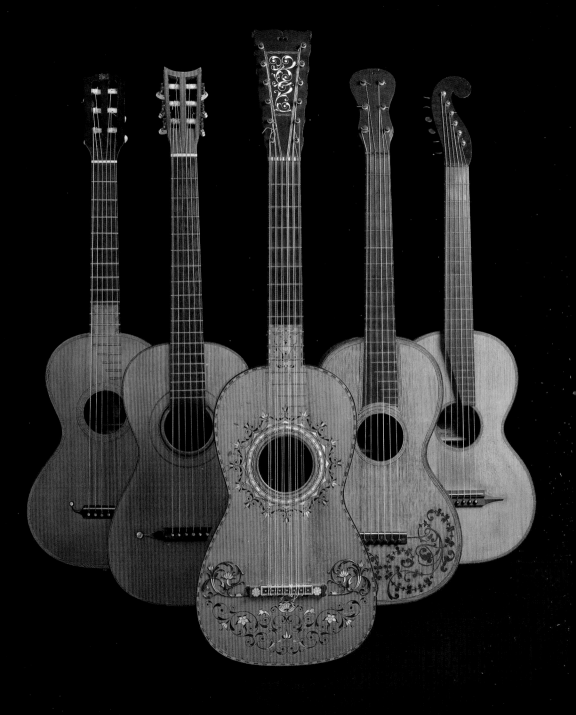

Contrabass serpent in C

JOSEPH AND RICHARD WOOD · UPPER HEATON, HUDDERSFIELD, ENGLAND, C.1840
LENT BY A. MYERS · MIMEd 2929

This is the only known example of a nineteenth-century contrabass serpent. Its snake-like coils are 16 feet (almost 5 metres) long and it is sometimes known as 'The Anaconda'. Serpents were traditionally used to play the bass parts alongside church choirs to support the bass singers and were an important military band instrument. Although the serpent resembles a woodwind instrument in construction with its leather-wrapped, wooden body, finger holes and keys, it a member of the brass family and is a distant ancestor of the tuba.

This instrument was made by two brothers at a time when the serpent was fading in popularity. It is awkward to hold, very heavy, and its enormous size makes it difficult to play. Nevertheless, the Wood brothers played the instrument for around 20 years in the Almondbury Church, Huddersfield and on occasion in the York Minster. They may have also played this serpent in local bands.

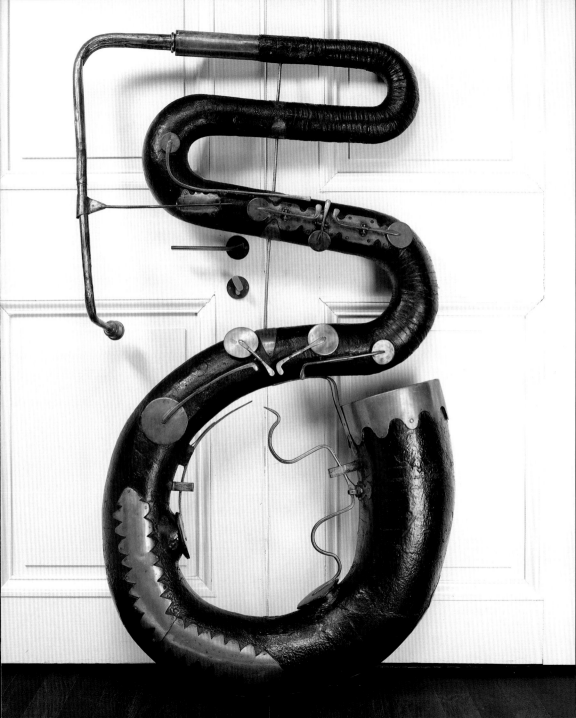

Guitar, 5 courses

MATTEO SELLAS · VENICE, ITALY, C.1640
ANNE MACAULAY COLLECTION · MIMEd 279

This delicate Baroque guitar is a superb instrument crafted by a master maker. It was made when the guitar was becoming popular in Europe and when its design was still heavily influenced by the lute. The instrument's small body has a curved back made of yew, cut so that each rib is half light and half dark, and thin strips of ebony. The soundboard features intricate inlaid floral vinework. A raised floral 'moustache' complements the bridge and the sound hole is decorated with a fine parchment rose. The guitar has five pairs of gut strings called courses. It has a gentle sound that would have suited small, intimate performances.

Inside the instrument is a label with the name Matteo Sellas (*c.*1600–1654), a master luthier who was known for his guitars and lutes. Like many luthiers working in Italy, Sellas was of German origin and was born in Füssen. He immigrated to Venice and in the 1620s, after completing his training, established his own prolific workshop where he employed a large number of apprentices. A number of highly decorative instruments with Sellas' signature can be found in public collections and he is considered to have been one of the finest luthiers of his day.

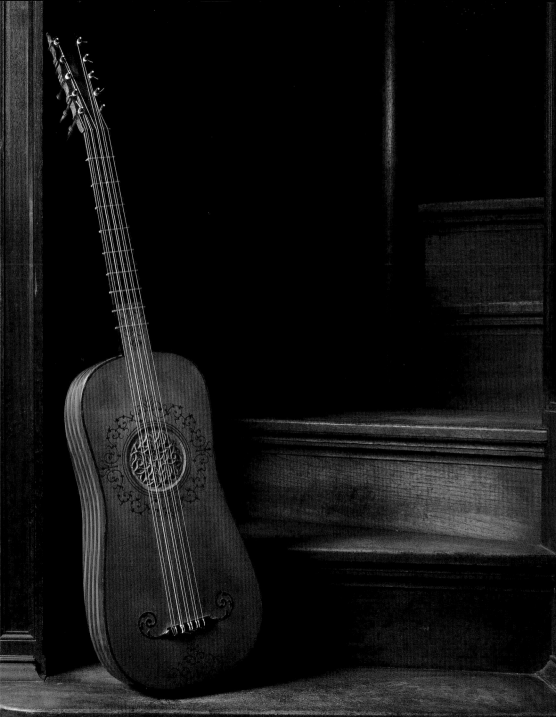

Pochette and kit

MIMEd 331

MIMEd 953

ABOVE Painted scenes of classical figures such as cupids playing lyres decorate the back of MIMEd 953.

These small bowed stringed instruments were made with a specific occupation in mind – that of the dancing master. Throughout the seventeenth and eighteenth centuries dancing masters taught the latest dance steps to ladies and gentlemen. Dancing was an important social skill, particularly during the courtship process, and dancing masters were in high demand. These instructors needed an instrument that was loud enough to be heard over the stamping of feet on wooden floors, while small enough to be stowed in a pocket when not being played.

The name pochette comes from the French for pocket. In England the instrument was called a kit, which may also have derived from the word pocket. Whereas the French pochette is boat shaped, kits are shaped like small violins or viols. The small string length and body size of these instruments required a different playing technique from that of a standard violin and often the bottom of the instrument would rest against the player's inner elbow or against the chest.

Both of these instruments have carved ornamental human heads. The fine carving was a way to show off the owner's status, and many of these instruments are a tour de force of the maker's art, often employing rare and precious materials such as ebony and mother-of-pearl.

KIT · ANONYMOUS · ENGLAND, MID-17TH CENTU
C. H. BRACKENBURY MEMORIAL COLLECTION ·
MIMEd 953

POCHETTE · JACQUES DU MESNIL · PARIS,
FRANCE, C.1660
REID COLLECTION · MIMEd 331

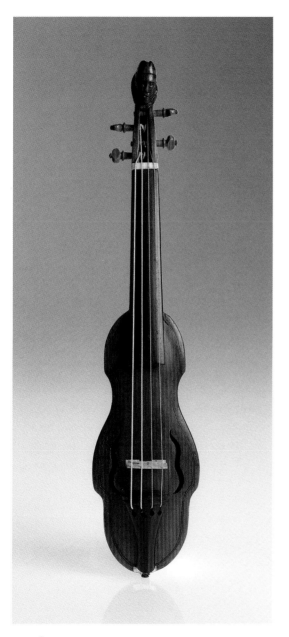

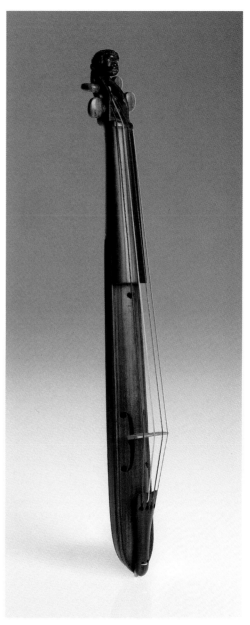

MIMEd 953

MIMEd 331

Dance drummer's drum kit

PREMIER · ENGLAND, 1930S

JAMES BLADES COLLECTION · MIMEd 2129, 2384–89,
2391–97, 2399, 2400, 2421, 2900, 2909, 2923, 2918, 3629

Although a very basic drum kit had been patented
at the end of the nineteenth century, early jazz and
dance drummers were the real drivers behind the
development of drum kit arrangements like this.
The design was an innovative way to assemble multiple
drums that could all be played by one musician.

This is a 'console' kit from approximately 1930.
It represents an approach to building an integrated
drum kit that anticipated the modern style of frame-
mounted kits. The three main drums: the bass,
snare and tam-tam, are mounted on a metal frame
called the console, which could be assembled off-
stage and wheeled into position in one go. The whole
assembly is dismountable and can fit in a modest-
sized case, making it ideal for a gigging drummer.

Over the years this drum kit has collected various
instruments from more modern periods. The cymbals
are typical of the 1930s and provided the characteristic
colour and effects of the 1930s dance band. This
drum kit also has a contraption tray that holds
additional small percussion instruments like a slap
stick, ratchet, temple blocks and various other
noisemakers. Named after the word 'contraption',
these early drum kits were known as 'trap sets',
a name that is still occasionally used today.

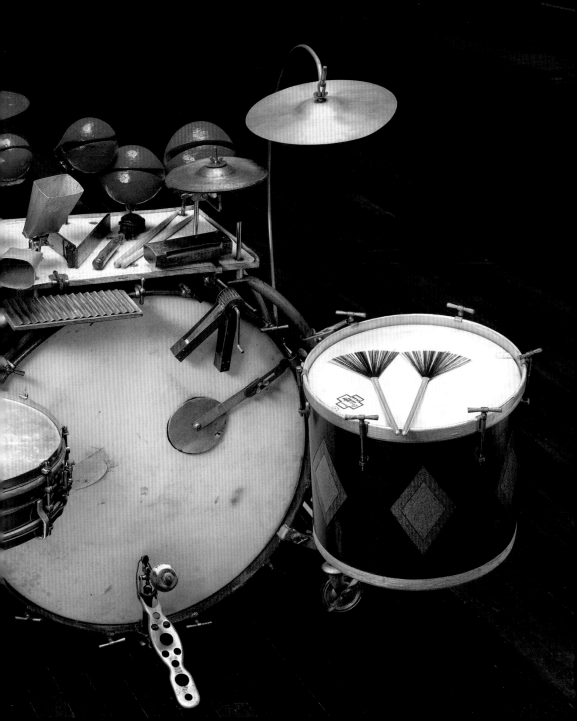

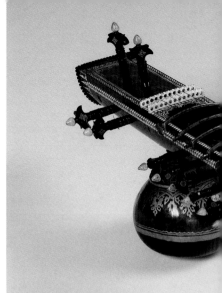

Mayuri, or taus

MAKER UNKNOWN · INDIA, 19TH CENTURY
LENT BY T. D. COLVILLE, W. H. A. COLVILLE
AND MRS R. E. COLQUHOUN · MIMEd 515

The mayuri, also called the taus, is a bowed stringed instrument which is played in north and central India. The instrument has very specific connections with Punjab, in particular with the Sikhs, and is used for the playing of devotional music. It is said to have been invented by the Guru Har Gobind (1595–1694). The two names for the instrument come from its distinctive shape; *mayuri* is Sanskrit for peacock and *taus* is the Persian equivalent. The peacock is associated with Saravisti, the goddess of music, and it appears in Indian poetry as a metaphor for courtship.

The instrument, with its graceful peacock shape, lends itself to beautiful decoration. This fine example is no exception. In addition to the elegantly carved body, the mayuri is finely painted with bright, colourful plumage. Between the legs of the bird a cobra rears up from the stand and the peacock holds a pearl in its mouth. The instrument would originally have had actual peacock feathers affixed to the small sound-hole, but these have been lost over time.

This instrument dates from the time when the mayuri was commonly played at nineteenth-century Indian courts. The four melody strings and fourteen sympathetic strings give the instrument a loud and rich sound that is deep and mellow in tone.

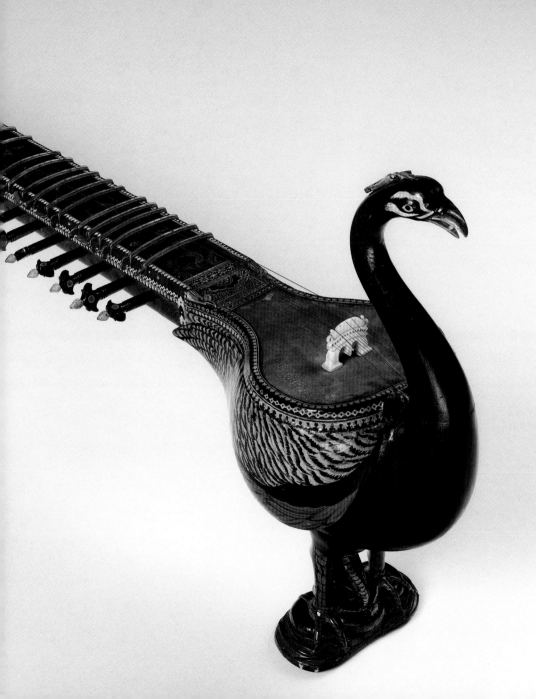

Chinese instruments collected by John Donaldson

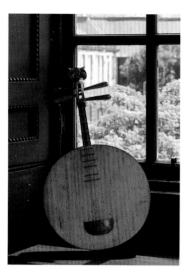

The University of Edinburgh began collecting musical instruments in the mid-nineteenth century when John Donaldson became the Reid Professor of Music. Donaldson used musical instruments as teaching tools in his classroom and he collected over 100 musical instruments over 20 years. Those instruments formed the foundations of the collection on display at St Cecilia's Hall today.

The musical instruments Donaldson collected span a variety of periods and regions and he seemed particularly interested in the instruments of China. These five examples are beautifully crafted string instruments. They would have featured in a variety of musical ensembles and their use dates back to antiquity.

YUEQUIN · MAKER UNKNOWN · CHINA, BEFORE 185
DONALDSON COLLECTION · MIMEd 443
ILLUSTRATED ABOVE LEFT

GUZHENG · MAKER UNKNOWN · SOUTH CHINA, 19TH CENTURY
DONALDSON COLLECTION · MIMEd 447
ILLUSTRATED ABOVE CENTRE

PIPA · MAKER UNKNOWN · CHINA, 19TH CENTURY
DONALDSON COLLECTION · MIMEd 442
ILLUSTRATED ABOVE RIGHT

SANXIAN · MAKER UNKNOWN · CHINA, BEFORE 188
DONALDSON COLLECTION · MIMEd 437
ILLUSTRATED OPPOSITE, LEFT

SIHU · MAKER UNKNOWN · CHINA, BEFORE 1888
DONALDSON COLLECTION · MIMEd 438
ILLUSTRATED OPPOSITE, RIGHT

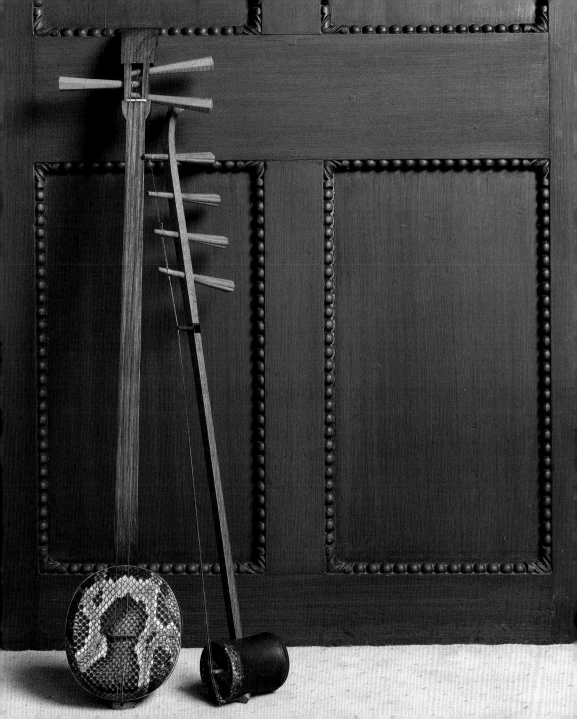

Dramyin

MAKER UNKNOWN · BHUTAN, EARLY 20TH CENTURY
GIFT OF PROFESSOR GEOFFREY SAMUEL · MIMEd 3677

This traditional Himalayan instrument is played
to accompany singing, dancing or storytelling
performances. Generally used for performing secular
music, in Bhutan, where this example comes from,
the dramyin is also played by Drukpa monks during
religious festivals – notable for being one of the very
few instances where the playing of a string instru-
ment is permitted inside a Bhutanese monastery, or
within Tibetan Buddhism in general.

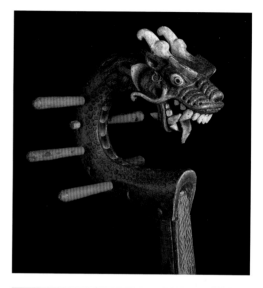

The name of the instrument translates to
'beautiful and melodious sound', and this colourfully
painted example pleases the eye as well as the ear.
The draymin is ornately decorated with religious
motifs and symbols such as a *dung dkar* (a white
conch trumpet), one of the eight auspicious symbols
of Tibetan Buddhism. There is an image of a fierce
deity painted above the spiral-shaped sound-holes.
This wrathful god has the power to destroy any
obstacles in the way of obtaining enlightenment and
acts as a guardian against demons, which are said
to be attracted to the dramyin's melodious sound.
The impressive C-shaped pegbox therefore finishes
with another fearsome creature designed to ward off
demons – a *chusing* (a type of sea monster) baring
its teeth.

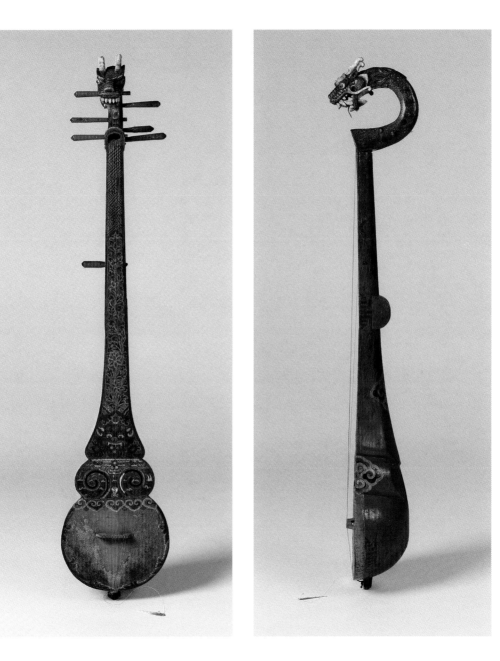

Sanza

MAKER UNKNOWN · SUB-SAHARAN AFRICA, 1880–1910
GLEN COLLECTION · MIMEd 413

The sanza, also called the mbira, comes in a wide variety of shapes, sizes and materials and has been played across Africa for thousands of years. It is a plucked instrument consisting of a number of metal tongues, called 'lamellae', which are placed over a wooden board or box. The tongues are held in position by a cross bar, leaving one end of each tongue free to be plucked. The plucking is usually done with the thumbs, which has led some people to call this instrument a 'thumb piano'. The pitch of a tongue is determined by its length, which can easily be altered by sliding the tongue back and forth under the cross bar. The longer the tongue, the lower the note. This instrument has additional wire wrapped around the tongues, giving the instrument a characteristic buzzing sound.

This sanza is part of the Glen Collection. The Glens are best known as a dynasty of Scottish bagpipe makers who were in business in Edinburgh for over 150 years. The Glens made and sold wind and percussion instruments as well as bagpipes and collected musical instruments. After the business closed in the early 1980s the University of Edinburgh acquired their substantial instrument collection, which includes wind, string and percussion instruments from around the world.

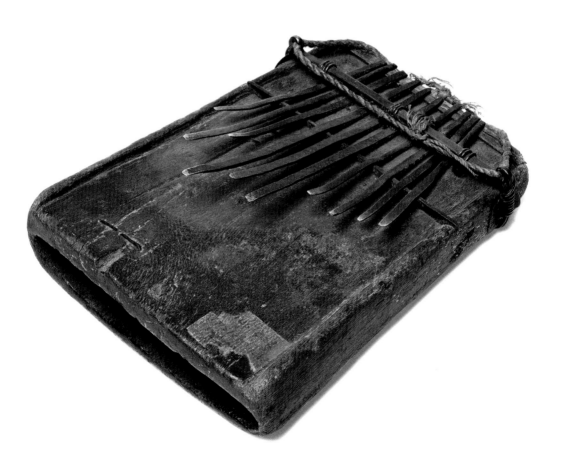

Published by Scala Arts & Heritage Publishers Ltd
10 Lion Yard, Tremadoc Road, London SW4 7NQ
www.scalapublishers.com

In association with St Cecilia's Hall, University of Edinburgh
50 Niddry Street, Edinburgh EH1 1LG
www.stcecilias.ed.ac.uk

First published in 2019
ISBN 978 1 78551 228 5

Edited by Laura Fox
Designed and typeset in Custodia Pro
by Nye Hughes, Dalrymple
Printed in Turkey

10 9 8 7 6 5 4 3 2 1

Front cover image: Viola da gamba by Matthias and
Augustinus Kaiser, c.1700, MIMEd 2878
Title page: Detail of double-manual harpsichord by
Jean Goermans, 1764, altered by Pascal Taskin, 1780s,
MIMEd 4329
Back cover image: Exterior of St Cecilia's Hall